Samplings from the Sea

— SAMPLER SERIES —

D0818134

**Rosemary
Makhan**

Dedication

This book is dedicated to my brothers, Stephen, Morris, and Leonard Brown, and to the memories of our growing up in Nova Scotia—where no matter where you live, you're not very far from the sea.

Acknowledgments

Thank you to the Victoria Quilters' Guild and especially to Karen Willoughby for inviting me to give workshops in Victoria, British Columbia, thus facilitating my first trip across Canada—from sea to sea—and giving me the inspiration for this quilt.

A special thanks to Kathy Jones for finishing her quilt and sharing it in this book.

Thanks to my husband, Chris, and my children, Candice and Kenneth, for their support and encouragement in my quiltmaking.

Also, thanks to the staff at That Patchwork Place for their faith in me and for making me feel part of their "family." The warmth, support, and enthusiasm they have shown mean a great deal to me.

Credits

Editor-in-Chief . Barbara Weiland
Technical Editor . Susan I. Jones
Managing Editor . Greg Sharp
Copy Editor . Liz McGehee
Proofreader . Tina Cook
Text and Cover Design . Kay Green
Typesetting . Julianna Reynolds
Photography . Brent Kane
Illustration and Graphics . Laurel Strand

Samplings from the Sea©
©1993 by Rosemary Makhan
That Patchwork Place, Inc., PO Box 118,
Bothell, WA 98041-0118
USA
Printed in the United States of America
98 97 96 95 94 93 6 5 4 3 2 1

Makhan, Rosemary,
 Samplings from the sea / Rosemary Makhan.
 p cm.
 ISBN 1-56477-043-5 :
 1. Patchwork—Patterns. 2. Quilting—Patterns 3. Seafaring life
in art. I. Title.
TT835.M2717 1993
746.9'7041—dc20
 93-32534
 CIP

Contents

Introduction

I made Samplings from the Sea because of my love for the sea and maritime themes. I hope this quilt will be made and enjoyed by people who love the water whether it be a brook, river, lake, sea, or ocean.

This quilt looks best in a cool color scheme that looks like water, such as blue or green. The quilt can look quite different, depending on the block placement. Look carefully at the quilts pictured on the front and back covers for additional inspiration. Feel free to add your own special touches to your quilt to make it unique.

General Directions

The general directions included here contain all the information necessary to plan and complete this special quilt. Step-by-step cutting and sewing directions are given for each block and the border. Follow the directions carefully. Be sure to cut the pieces for the sashing *before* you cut the pieces for each block.

Fabric Selection

Consult the color photos on the front and back covers for help in selecting the fabrics for your quilt. For best results, use 100% cotton fabrics that have been washed to remove sizing and to ensure that the colors will not run. In the quilt shown on the cover, I used a variety of blues and creamy white, and the directions for the quilt are written for these colors. If you prefer, select fewer fabrics, remembering to buy more of each.

Yardage requirements are based on a usable width of 42" after preshrinking. You will probably have fabric left over to add to your collection.

Cutting

I recommend rotary cutting for most of the pieces in this quilt, but you will need to make templates for cutting some shapes with irregular measurements. All cutting measurements include the required ¼"-wide seam allowances. (For a refresher course on rotary cutting, see *Shortcuts: A Concise Guide to Rotary Cutting*, by Donna Lynn Thomas.)

Making Templates for Pieced Blocks

All templates include ¼"-wide seam allowances.

1. Trace the templates onto clear or frosted plastic to make durable, accurate templates (stiff pattern pieces). You can mark on plastic template material with a fine-line permanent marking pen. This provides an accurate line that will not smudge. Cut out the template carefully just inside the line so that the pieces will fit together perfectly.

2. Mark the template number and grain-line arrow on each template. This line is necessary for correctly aligning the template with the grain line of your fabric.

Set-in Seams

Several of the blocks in this quilt require set-in seams. Set-in seams are necessary when the only way to add a piece to a block is to stitch the piece in two stages.

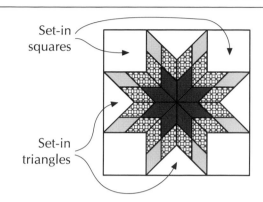

Set-in squares

Set-in triangles

You usually sew this type of seam from the inside corner to the outer edge. This is also known as Y-seam construction. Directions for adding pieces that require set-in seams are included with each block as required.

To prepare the pieces for set-in seams, mark the inside corner of the pieces to be joined. Mark a tiny dot at the points where the seam lines intersect.

To piece all of these set-in seams accurately, match the dots at the seam intersections by placing a pin through each one before stitching. Stitch from the inner point to the outer corner, ending the stitching ¼" from the raw edges. Backstitch. Press.

Curved Seams

Some blocks have curved pieces that require special handling. One piece has a concave curve and the other a convex curve.

1. After cutting the pieces from the appropriate templates, mark the center points on each piece for matching purposes.

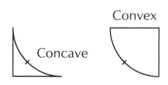

Convex

Concave

Mark centers.

2. To make the concave curve fit the convex curve, make ⅛"-deep clips into the seam allowance. Make only a few clips at first and make more later if needed.

Center

Make ⅛" deep clips.

3. Pin the concave piece to the convex curve with centers matching, using plenty of pins. Stitch. Press the seam toward the convex piece.

Center.

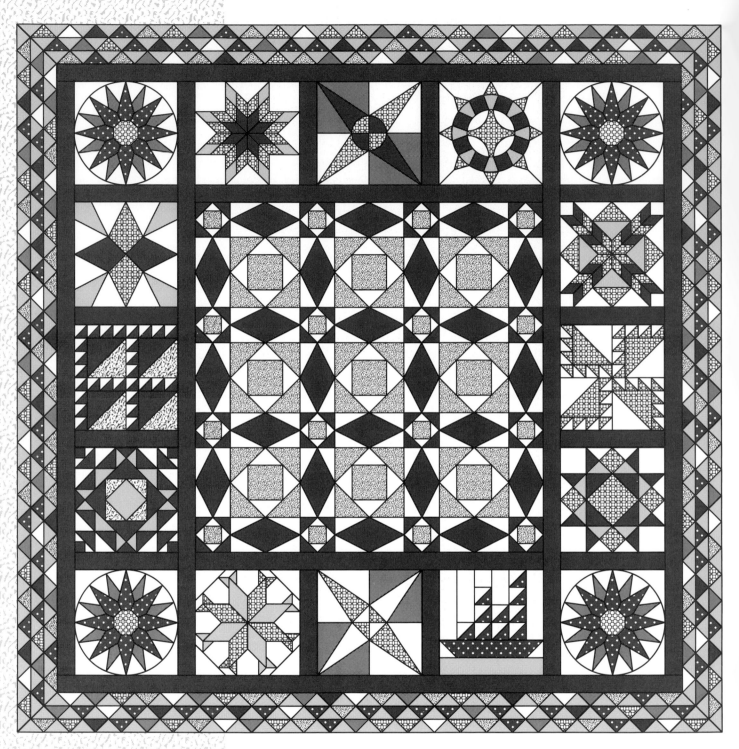

Quilt Plan
Finished Size: 81" x 81"

Materials: 44"-wide fabric

⅓ yd. each of 5 or more medium blue prints for blocks
½ yd. of medium blue solid or tone-on-tone print for blocks and border
1 yd. medium blue print for Storm at Sea center and blocks
⅓ yd. each of 4 or more dark blue prints for blocks and border
2¾ yds. dark blue solid (or tone-on-tone print) for blocks and sashing
4½ yds. cream solid or tone-on-tone print for background
5 yds. light to medium blue print or solid for backing
¾ yd. dark blue print or solid for binding
90" x 90" piece of batting

Cutting for Sashing

All measurements include ¼"-wide seam allowances.
Cut strips across the width of the fabric.
Cut sashing strips first; use the remaining fabric for the blocks.

From the dark blue solid, cut:
8 strips, each 2½" x 42", for vertical sashing pieces.
Sew strips together in pairs to yield 4 long strips.

Make 4.

4 strips, each 2½" x 42", for horizontal
top and bottom sashing strips.
Sew strips together in pairs to yield 2 long strips.

Make 2.

2 strips, each 2½" x 42", for top and bottom of the Storm
at Sea centerpiece.
4 strips, each 2½" x 42", for block sashing pieces.
Crosscut into 12 strips, each 2½" x 12½".

To avoid confusion while piecing the blocks,
label these strips as sashing pieces and set aside.

Storm at Sea Centerpiece

*Small skill is gained by those who
cling to ease;
The hardy sailor hails from
stormy seas.*
 Old Saying

Block 1 - Make 16.
Finished size: 4"

Block 2 - Make 9.
Finished size: 8"

Block 3 - Make 24.
Finished size: 4" x 8"

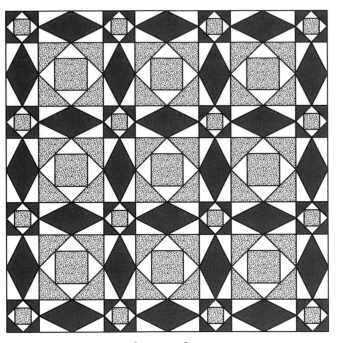

Storm at Sea
Finished size: 40" x 40"

The central Storm at Sea design is composed of the three different blocks shown at left. The same three fabrics are repeated in each block. All measurements include ¼"-wide seam allowances. Cut strips across the width of the fabric.

Block 1

Cutting

Piece A
Cut 1 strip, 2½" x 42", from medium blue print.
Crosscut into 16 squares, each 2½" x 2½".

Piece B
Cut 1 strip, 3¼" x 42", and 1 strip, 3¼" x 21", from background fabric.
Crosscut into 16 squares, each 3¼" x 3¼". Stack squares
and cut twice diagonally to yield 64 triangles.

Piece C
Cut 2 strips, each 2⅞" x 42", and 1 strip, 2⅞" x 21",
from dark blue solid. Crosscut into 32 squares, each 2⅞" x 2⅞".
Stack the squares and cut in half diagonally to yield 64 triangles.

Directions

1. Sew a Piece B to opposite sides of Piece A, then to the remaining sides of the unit.
2. Sew a Piece C to opposite sides of A/B Unit, then to the remaining sides to complete the block. Make 16.

Block 2

Cutting

Piece D
Cut 1 strip, 4½" x 42", from medium blue print.
Crosscut into 9 squares, each 4½" x 4½".

Piece E
Cut 1 strip, 5¼" x 42", and 1 strip, 5¼" x 10½", from background fabric. Crosscut into 9 squares, each 5¼" x 5¼".
Stack squares and cut twice diagonally to yield 36 triangles.

Piece F
Cut 2 strips, each 4⅞" x 42", and 1 strip, 4⅞" x 10½", from medium blue print. Crosscut into 18 squares, each 4⅞" x 4⅞". Stack squares and cut in half diagonally to yield 36 triangles.

Directions

1. Sew a Piece E to opposite sides of Piece D, then to the remaining sides of the unit.
2. Sew a Piece F to opposite sides of D/E unit, then to the remaining sides to complete the block.

Block 3

Cutting

Piece G

Cut 24 Template G (page 11) from dark blue solid. Mark the seam intersections as shown for set-in seams on page 5.

Piece H

Cut 6 strips, each 2⅝" x 42", from background fabric.
Crosscut into 48 rectangles, each 2⅝" x 5¼".
Cut rectangles in half diagonally to yield 96 triangles. Mark the ¼" seam intersections on the triangles as shown for set-in seams on page 5.

Directions

1. Sew a Piece H to opposite sides of Piece G, carefully matching seam intersecton dots.
2. Sew a piece H to the remaining sides of the unit to complete the block.

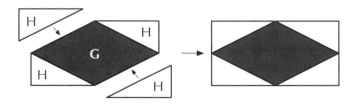

Centerpiece Assembly

1. Assemble 4 vertical rows as shown at left.

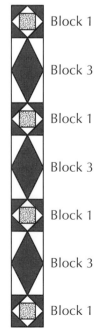

Block 1

Block 3

Block 1

Block 3

Block 1

Block 3

Block 1

Row 1
Make 4.

2. Assemble 3 vertical rows as shown.

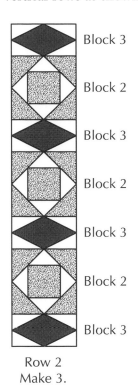

Block 3

Block 2

Block 3

Block 2

Block 3

Block 2

Block 3

Row 2
Make 3.

3. Join all vertical rows, referring to the Storm at Sea diagram below.

Row 1 Row 2 Row 1 Row 2 Row 1 Row 2 Row 1

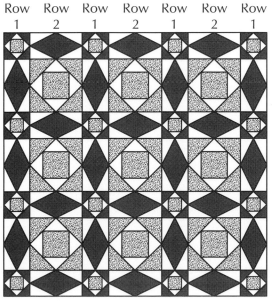

Storm at Sea Assembly Diagram

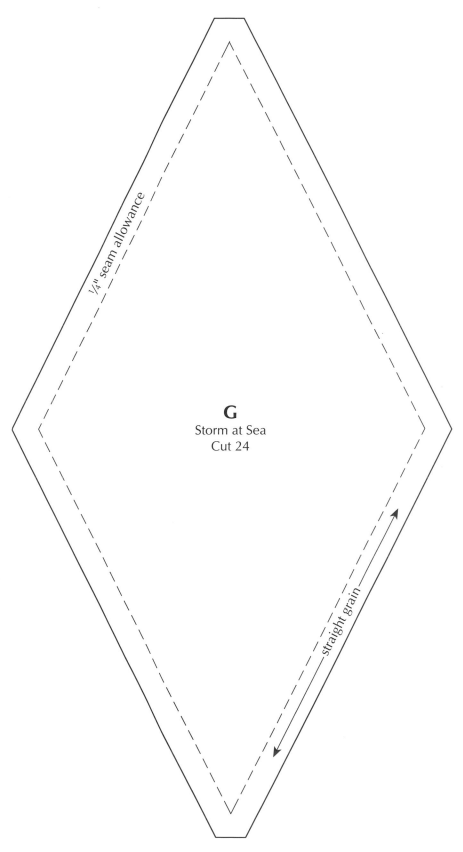

G
Storm at Sea
Cut 24

¼" seam allowance

straight grain

Lost Ship

"Suppose that this here vessel," says
the Skipper with a groan,
"Should lose 'er bearin's, run away,
and bump upon a stone;
Suppose she'd shiver and go down,
when save ourselves we couldn't—"
The mate replies, "O, blow me eyes,
suppose again she shouldn't."

(Wallace Irwin,
"Sorrows of a Skipper")

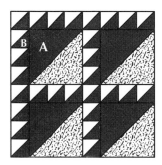

Lost Ship
Finished size: 12"

Cutting

All measurements include ¼"-wide seam allowances.
Cut strips across the width of the fabric.

Piece A

Cut 2 squares, each 5⅜" x 5⅜", from dark blue solid. Cut 2 squares, each 5⅜" x 5⅜", from 1 medium blue print. Cut squares in half diagonally to yield 4 dark blue triangles and 4 medium blue triangles.

Piece B

Cut 1 strip, 2⅜" x 42", from dark blue solid and 1 from background fabric. Crosscut each strip into 14 squares, 2⅜" x 2⅜". Cut squares in half diagonally to yield 28 triangles from each fabric.

Directions

1. Sew dark blue triangle A and medium blue triangle A together to form a half-square triangle unit (Unit #1).

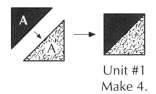

Unit #1
Make 4.

2. Sew dark blue solid piece B to background piece B to make 28 Unit #2.

Unit #2
Make 28.

3. Sew 3 Unit #2 together as shown.

Make 4.

4. Sew 4 Unit #2 together as shown.

Make 4.

5. Sew units together as shown to complete each quarter square of the block.

Make 4.

6. Sew the completed units together in 2 vertical rows.

Make 2.

7. Join the vertical rows to complete the block.

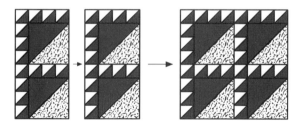

Waves of the Sea

*Roll on, thou deep and dark blue
 ocean—roll!
Ten thousand fleets sweep over thee
 in vain;
Man marks the earth with ruin—his
 control
Stops with the shore.*

(Lord Byron,
"Childe Harold's Pilgrimage")

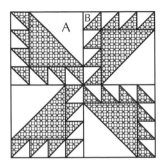

Waves of the Sea
Finished size: 12"

Cutting

*All measurements include ¼"-wide seam allowances.
Cut strips across the width of the fabric.*

Piece A

Cut 2 squares, each 5⅜" x 5⅜" from dark blue print.
Cut 2 squares, each 5⅜" x 5⅜", from background fabric.
Cut squares in half diagonally to yield 4 dark blue print triangles
and 4 background triangles.

Piece B

Cut 1 strip, 2⅜" x 42", from the dark blue print and 1 from
the background fabric. Crosscut each strip into 14 squares,
each 2⅜" x 2⅜". Cut squares in half diagonally to yield
28 triangles from each fabric.

Directions

1. Sew 1 dark blue print triangle A and 1 background triangle A together to
 form a half-square triangle unit (Unit #1).

Unit #1
Make 4.

2. Sew 1 dark blue print piece B to 1 background piece B to make Unit #2.

Unit #2
Make 28.

3. Sew 3 Unit #2 together as shown.

Make 4.

4. Sew 4 Unit #2 together as shown.

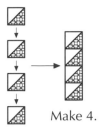

Make 4.

5. Sew units together as shown to complete each quarter square of the block.

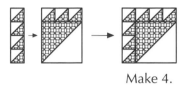

Make 4.

6. Sew the completed units together in 2 vertical rows, paying careful attention to placement.

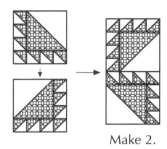

Make 2.

7. Join the vertical rows to complete the block, positioning the pieces to create a "pinwheel" effect.

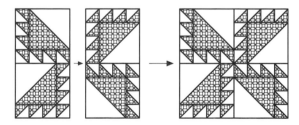

Crossed Canoes

I've travelled about a bit in my time,
And of troubles I've seen a few;
But found it better in every clime
To paddle my own canoe.
 (Harry Clifton)

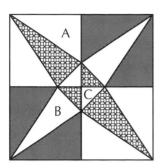

Crossed Canoes
Finished size: 12"

Cutting

All measurements include ¼"-wide seam allowances.
Use template on page 17.

Piece A

Cut 2 rectangles, each 4⅝" x 7¼", from background
fabric and 2 from medium blue print. Stack rectangles,
right sides together, and cut in half diagonally to yield
2 triangles and 2 reversed triangles from each fabric.
Mark the seam intersections on the triangles as shown
for set-in seams on page 5.

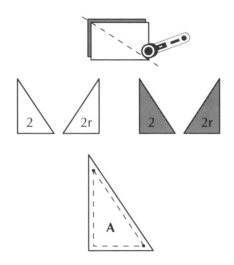

Piece B

Cut 2 Template B from the medium blue print
and 2 from the background fabric. Mark the seam intersections
on the triangles as shown for set-in seams on page 5.

Piece C

Cut 1 square, 2⅞" x 2⅞", from medium blue print
and 1 from background fabric. Stack squares and cut in
half diagonally to yield 2 triangles from each fabric.

Directions

1. Sew a Piece A to both sides of Piece B, carefully matching seam intersection dots. Follow the diagram for the placement of prints.

Make 2. Make 2.

2. Sew Piece C to Piece B as shown.

Make 2. Make 2.

3. Sew the units together in 2 horizontal rows as shown.

Make 2.

4. Join the 2 rows together to complete the block.

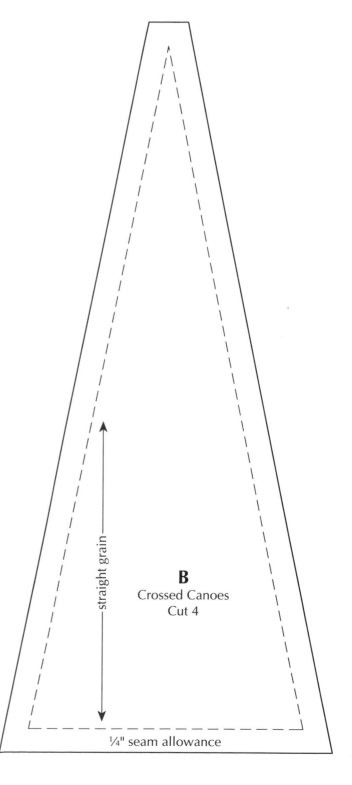

straight grain

B
Crossed Canoes
Cut 4

¼" seam allowance

Compass

Oh, East is East, and West is West,
and never twain shall meet,
Till Earth and Sky stand presently
at God's great Judgement Seat;
(Rudyard Kipling,
"The Ballad of East and West")

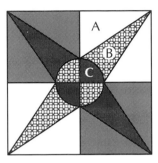

Compass
Finished size: 12"

Cutting

All measurements include ¼"-wide seam allowances.
Cut strips across the width of the fabric. Use Templates B
and C on page 19.

Piece A

Cut 1 strip, 4⅝" x 18", from background fabric and 1 from medium blue print. Stack the strips right sides together. Crosscut into 2 rectangles, each 4⅝" x 7¼". Cut rectangles in half diagonally to yield 2 triangles and 2 triangles reversed from each fabric. Mark the seam intersections on the triangles as shown for set-in seams on page 5.

Rectangles are
right sides together.

Piece B

Cut 2 Template B from medium blue print and 2 from dark blue solid. Mark the seam intersections as shown for set-in seams on page 5.

Piece C

Cut 2 Template C from medium blue print
and 2 from dark blue solid.

Directions

1. Sew a Piece A to both sides of each Piece B, following the diagram shown for the placement of prints.

Make 2. Make 2.

2. Sew Piece C to Piece B as shown, following the directions on page 5 for curved seams.

Make 2. Make 2.

3. Sew the units together in 2 horizontal rows as shown, paying careful attention to print placement.

Make 2.

4. Join the 2 rows to complete the block.

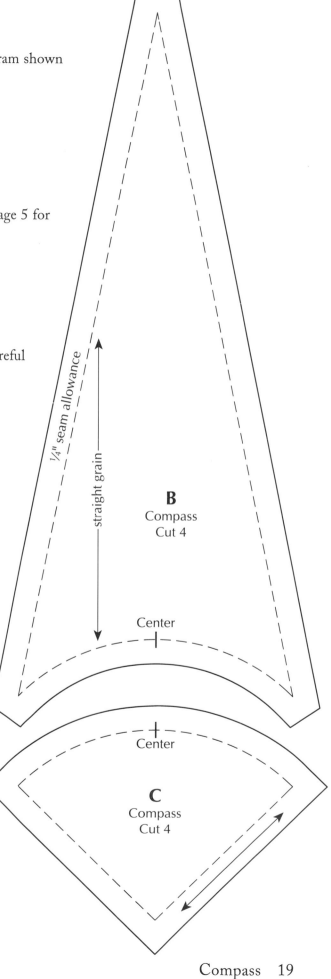

1/4" seam allowance

straight grain

B
Compass
Cut 4

Center

Center

C
Compass
Cut 4

Compass 19

Beacon Lights

When the weary day is over
And the world has gone to rest,
When my little bark is dancing o'er
the foam,
Like a dove at night returning
To the shelter of her nest,
Seeks my heart again the beacon
light of home.
 (George F. St. Clair)

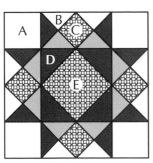

Beacon Lights
Finished size: 12"

Cutting

All measurements include ¼"-wide seam allowances.

Piece A
Cut 4 squares, each 3½" x 3½", from background fabric.

Piece B
Cut 2 squares, each 4¼" x 4¼", from background fabric,
2 from medium blue solid, and 2 from dark blue solid.
Stack and cut the squares twice diagonally to yield
8 triangles from each fabric.

Piece C
Cut 4 squares, each 2⅝" x 2⅝", from medium blue print.

Piece D
Cut 2 squares, each 3⅞" x 3⅞", from dark blue solid.
Cut squares in half diagonally to yield 4 triangles.

Piece E
Cut 1 square, 4¾" x 4¾", from medium blue print.

Directions

1. Sew a Piece D to opposite sides of square E, then to the remaining two sides of each square as shown for the center unit.

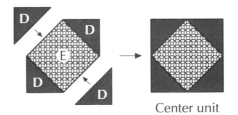

Center unit

2. Sew a Piece B of background fabric to each side of Piece C.

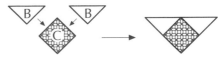

Make 4.

3. Sew a dark blue solid Piece B and a medium blue solid Piece B together to make 4 units and 4 reversed units as shown.

Make 4. Make 4 reversed.

4. Sew a unit made in step 3 to each side of the B/C/B unit made in step 2.

Make 4.

5. Sew the units together in 3 vertical rows as shown.

Make 2. Make 1.

6. Join the vertical rows to complete the blocks.

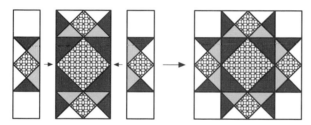

Tall Ship

I must down to the seas again, to
the lonely sea and the sky,
And all I ask is a tall ship and a
star to steer her by . . .
(John Masefield, "Sea Fever")

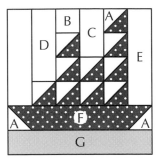

Tall Ship
Finished size: 12"

Cutting

All measurements include ¼"-wide seam allowances.

Piece A

Cut 5 squares, each 2⅞" x 2⅞", from dark blue print.
Cut 6 squares, each 2⅞" x 2⅞", from background fabric.
Cut squares in half diagonally to yield 10 dark blue print triangles and 12 background fabric triangles.

Piece B

Cut 1 square, 2½" x 2½", from background fabric.

Piece C

Cut 1 rectangle, 2½" x 4½", from background fabric.

Piece D

Cut 1 rectangle, 2½" x 6½", from background fabric.

Piece E

Cut 2 rectangles, each 2½" x 8½", from background fabric.

Piece F

Cut 1 rectangle, 2½" x 12½", from dark blue print.
Use Trimming Template F on page 23 to cut away the 2 bottom corners of Piece F. To make this easy, cut the template from template plastic or paper and tape to the underside of a Bias Square, then cut as shown.

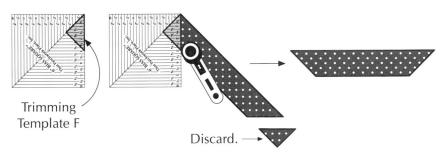

Trimming
Template F

Discard.

Piece G

Cut 1 rectangle, 2½" x 12½", from medium blue solid.

Directions

1. With right sides together, sew a dark blue print Piece A to a background Piece A to make a half-square triangle unit.

Make 10.

2. Using the half-square triangle units and pieces B, C, D, and E, piece the 6 vertical rows as shown. Sew the rows together.

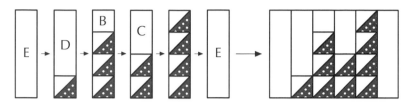

3. Sew a background triangle Piece A to each end of Piece F.

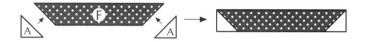

4. Join the pieced units, adding Piece G at the bottom to complete the block.

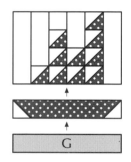

Trimming Template
F
Tall Ships

(Do not add seam allowances.)

Lighthouse

Let the lower lights be burning.
Send a gleam across the wave!
Some poor fainting, struggling
seaman
You may rescue, you may save.
(Philip Paul Bliss,
hymn)

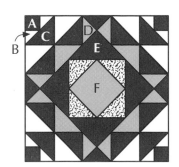

Lighthouse
Finished size: 12"

Cutting

All measurements include ¼"-wide seam allowances.
Use Templates A and B on page 25.

Piece A
Cut 4 Template A from dark blue solid.

Piece B
Cut 8 Template B from background fabric.

Piece C
Cut 6 squares, each 3¼" x 3¼", from dark blue solid.
Cut 4 squares, each 3¼" x 3¼", from background fabric.
Cut 2 squares, each 3¼" x 3¼", from medium blue solid.
Cut 2 squares, each 3¼" x 3¼", from medium blue print.
Stack squares and cut in half diagonally to yield 12 dark blue solid,
8 background, 4 medium blue solid, and 4 medium blue print triangles.
Place no more than 4 squares in each stack.

Piece D
Cut 1 square, 3⅝" x 3⅝", from dark blue solid.
Cut 2 squares, each 3⅝" x 3⅝", from medium blue solid.
Stack squares and cut twice diagonally to yield
4 dark blue solid triangles and 8 medium blue solid triangles.

Piece E
Cut 2 squares, each 4¼" x 4¼", from dark blue solid.
Cut squares in half diagonally to yield 4 triangles.

Piece F
Cut 1 square, 3⅞" x 3⅞", from medium blue solid.

Directions

1. Sew a medium blue print Piece C to opposite sides of Piece F, then to the remaining two sides as shown.

2. Sew a dark blue Piece E to opposite sides of the center unit, then to the remaining two sides of the unit.

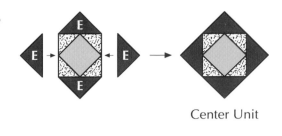

Center Unit

3. Sew a background Piece B to Piece A for the corner units.

Make 4.

4. Sew a background Piece C to each short side of a dark blue Piece C for the corner units.

Make 4.

5. Using the remaining Pieces C and D, piece the units shown below.

Make 2. Make 2.

6. Using the pieced sections made in steps 3, 4, and 5, assemble 2 Corner Unit A and 2 Corner Unit B.

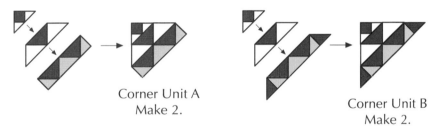

Corner Unit A
Make 2.

Corner Unit B
Make 2.

7. Sew a Corner Unit A to opposite sides of the center unit.

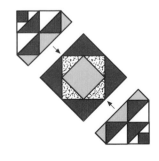

¼" seam allowance

A
Lighthouse
Cut 4

8. Add a Corner Unit B to the remaining sides of the center unit to complete the block.

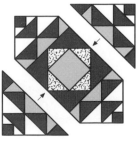

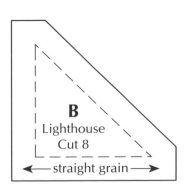

B
Lighthouse
Cut 8

straight grain

Lighthouse 25

Ship's Wheel (variation)

*And the stately ships go on
To their haven under the hill;
But O, for the touch of a vanish'd
 hand,
And the sound of a voice that is still!*
 (Alfred, Lord Tennyson,
 "Break, Break, Break")

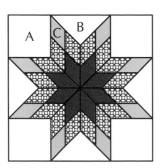

Ship's Wheel (variation)
Finished size: 12"

Cutting

*All measurements include ¼"-wide seam allowances.
Cut strips across the width of the fabric.*

Piece A

Cut 4 squares, each 4" x 4", from background fabric.

Piece B

Cut 1 square, 6¼" x 6¼", from background fabric.
Cut square twice diagonally to yield 4 triangles.

Piece C

Cut 1 strip, 1¾" x 42", from medium blue solid,
2 strips, each 1¾" x 42", from medium blue print,
and 1 strip, 1¾" x 42", from dark blue solid for diamond units.
Sew the medium blue solid strip to a medium blue print strip
along one long edge. Sew the remaining medium blue print strip
to the dark blue solid strip along one long edge as shown.

Begin cutting strip-pieced diamond units at the left end
of each pieced strip. Place your ruler at a 45° angle to the bottom
edge and cut 8 segments, each 1¾"-wide, from each pieced strip.

Cut 8. Cut 8.

Directions

1. Sew diamond segments, Piece C, together in pairs as shown to make a
 diamond unit.

2. Mark the seam intersections on the diamond units. To make the center star, make 4 chevron units by sewing the diamond units together in pairs. Stitch in the direction of the arrow and end the stitching ¼" from the inside corner at the marked seam intersection. Backstitch.

3. To make a half-star unit, sew the chevrons together in 2 pairs, stitching in the direction of the arrows. End stitching ¼" from the corner marked by dots.

Make 2.

4. Join the half-star units to complete the star, beginning and ending the stitching ¼" from each raw edge at the marked seam intersections.

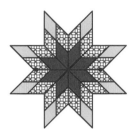

5. Mark the seam intersection at the point of each triangle, Piece B. Insert triangles. Match the seam intersection at the point of the triangle to the seam intersection at the inside corner of the star-point unit. Pin in place. Stitch in the direction of the arrow. Backstitch. Repeat with the remaining side of the triangle. Press the seams toward the pieced diamonds.

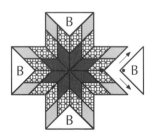

6. Mark the seam intersection at one corner of each square, Piece A. Add squares, Piece A, to the remaining star points, stitching in the direction of the arrows. Backstitch. Press the seams toward the pieced diamonds.

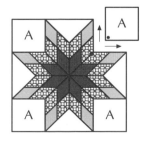

Fish

I never lost a little fish—yes, I am
free to say
It always was the biggest fish I caught
that got away.

(Eugene Field,
"Our Biggest Fish")

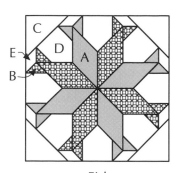

Fish
Finished size: 12"

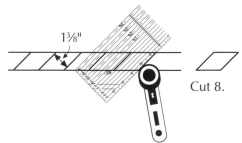

Cut 8.

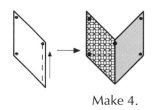

Make 4.

Cutting

All measurements include ¼"-wide seam allowances.
Cut strips across the width of the fabric.
Use Template D on page 29.

Piece A

Cut 1 strip, 2⅝" x 21", from medium blue solid and 1 from
dark blue print. At the left end of each strip, place your ruler at a
45° angle to a long edge of the strip and cut 4 diamond segments,
each 2⅝" wide, from each strip.

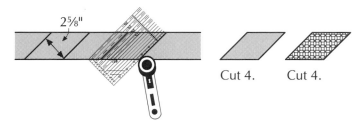

Cut 4. Cut 4.

Piece B

Cut 4 squares, each 2⅛" x 2⅛", from medium blue solid.
Cut 4 squares, each 2⅛" x 2⅛", from dark blue print.
Cut squares in half diagonally to yield 8 medium blue solid triangles and
8 dark blue print triangles.

Piece C

Cut 2 squares, each 4⅜" x 4⅜", from background fabric.
Cut squares in half diagonally to yield 4 triangles.

Piece D

Cut 8 Template D from background fabric.

Piece E

Cut 1 strip, 1⅜" x 21", from background fabric.
Place your ruler at a 45° angle to the bottom long edge of the strip
and cut 8 diamond segments, each 1⅜" wide as shown.
Make sure that each 1⅜"-wide cut is parallel to the first cut.

Directions

1. Mark the seam intersections on the diamond
 segments, Piece A. Follow the directions for
 set-in seams on page 5.

Mark seam
intersections.

2. To make the center star, make 4 chevron units, using the medium blue and
 dark blue diamonds, Piece A. Stitch in the direction of the arrow, ending the
 stitching ¼" from the raw edge at the marked seam intersection. Backstitch.
 Press seams toward the dark blue diamonds.

3. To make a half-star unit, sew the chevrons together in 2 pairs, stitching in the direction of the arrows. End stitching ¼" from the raw edge at the marked seam intersection. Press seams toward the dark blue diamonds.

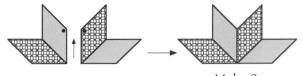

Make 2.

4. Join the half-star units to complete the star, beginning and ending stitching ¼" from each raw edge as indicated by the dots in the illustration. Press.

Begin and end stitching at the dots.

5. Sew a Piece B to each side of each Piece D. Mark the seam intersection at the point of each Piece D.

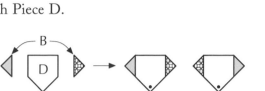

Make 4. Make 4.

6. Sew Unit B/D/B between the fish bodies, stitching in the direction of the arrows and ending stitching at the seam intersections indicated by the dots in the illustration.

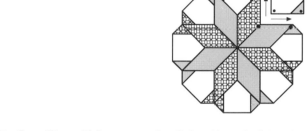

7. Sew Piece E between the fish tails, stitching in the direction of the arrows.

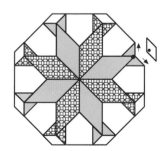

8. Sew a Piece C to each corner to complete the block.

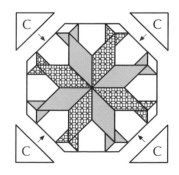

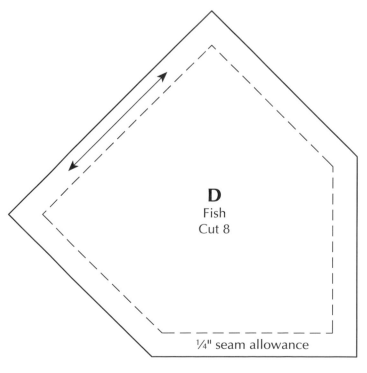

D
Fish
Cut 8

¼" seam allowance

Time and Tide

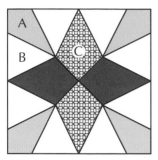

Time and Tide
Finished size: 12"

Cutting

All measurements include ¼"-wide seam allowances. Use Templates A, B, and C on page 32. Mark the seam intersections on all pieces as shown for set-in seams on page 5.

Piece A
Cut 4 Template A from medium blue solid.

Piece B
Cut 8 Template B from background fabric.

Piece C
Cut 2 Template C from dark blue solid and 2 from medium blue print.

Directions

Note: To piece all of these seams accurately, match the dots at the seam intersections by placing a pin through each one before stitching. Stitch from the inside point to the outer point in the direction of the arrows. End the stitching ¼" from the raw edges. Backstitch.

1. Sew a background Piece B on each side of a Piece A to make Unit #1.

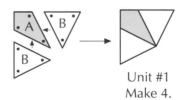

Unit #1
Make 4.

2. Sew a medium blue Piece C to a dark blue Piece C to make Unit #2. Stitch in the direction of the arrow, ending the stitching ¼" from the raw edge at the marked seam intersection.

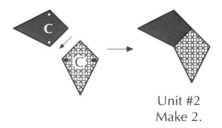

Unit #2
Make 2.

3. Sew Unit #1 to Unit #2, stitching in the direction of the arrows.

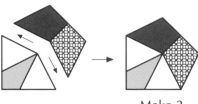

Make 2.

4. Sew the two completed units together as shown, beginning and ending the stitching at the marked seam intersection ¼" from the raw edges.

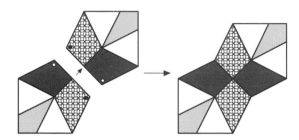

5. Add the remaining #1 units to complete the block, stitching in the direction of the arrows.

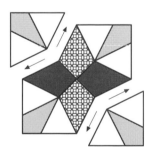

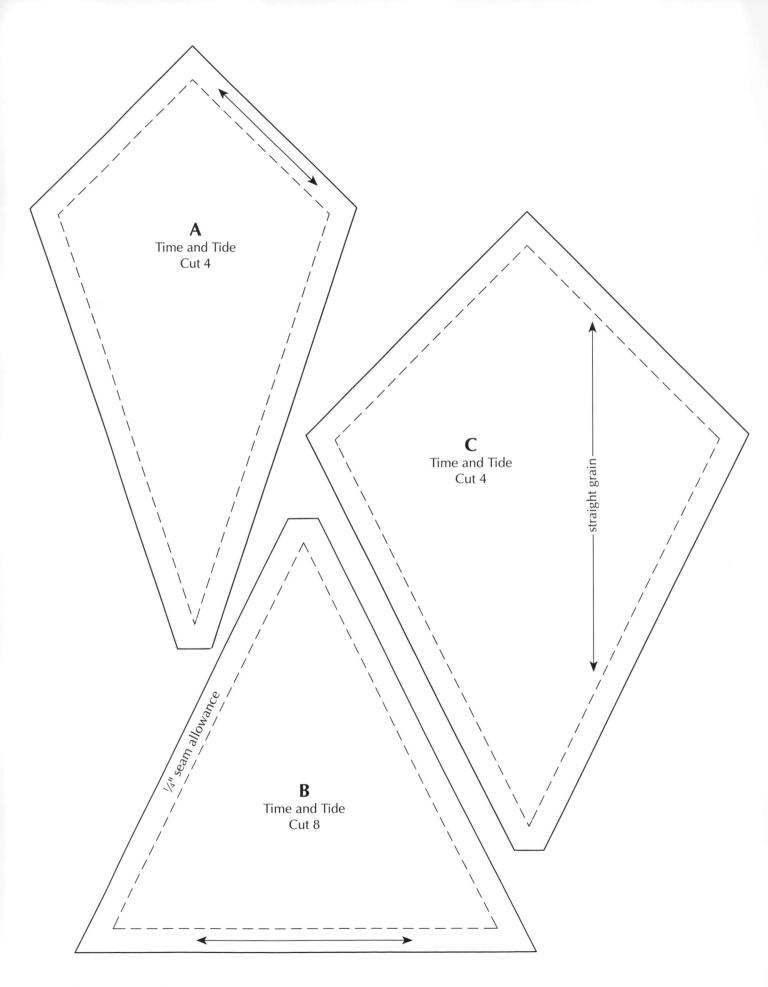

A
Time and Tide
Cut 4

C
Time and Tide
Cut 4

straight grain

¼" seam allowance

B
Time and Tide
Cut 8

St. Elmo's Fire

Cutting

All measurements include ¼"-wide seam allowances.
Use Templates A, B, and C on page 35.

Piece A

Cut 4 Template A from background fabric.

Piece B

Cut 8 Template B from background fabric.
Cut 4 Template B from medium blue solid and
4 from medium blue print.

Piece C

Cut 16 of Template C from dark blue solid and 16 from
medium blue print. Mark the seam intersections on the
C pieces by marking a dot on the fabric for matching purposes.

Directions

1. Sew a medium blue solid Piece B to each medium blue print Piece B to make 4 half-square triangle units.

Make 4.

2. Sew a background Piece B to two sides of each half-square triangle unit. Mark the seam intersection at the point with a dot.

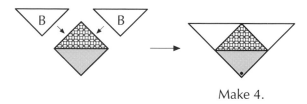

Make 4.

3. Sew the dark blue solid and medium blue print diamonds together in the order shown to make mirror-image rows. Repeat with the remaining diamonds to make a total of 4 sets.

4. Join the rows to make a unit, stitching in the direction of the arrow. Begin stitching at the inside point and stitch to the dot at the seam intersection. Backstitch. Press.

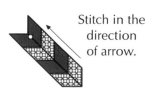

Stitch in the direction of arrow.

Make 4.

Yes, our lives are merely strange dark interludes in the electrical display of God the Father.
(Eugene O'Neill, "Strange Interlude")

During a storm at sea, sailors often saw electrical charges around the masts and rigging of the ship. The sailors prayed to their patron saint, St. Elmo, to deliver them from this fire and from the storm.

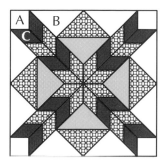

St. Elmo's Fire
Finished size: 12"

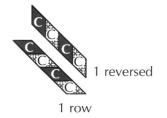

1 reversed

1 row

Make 4 sets.

5. Sew 2 of the completed units together, stitching in the direction of the arrow and ending at the seam intersections indicated by the dots in the diagram. Match the dots at the seam intersections by placing a pin through each one before stitching. Repeat with the remaining 2 units.

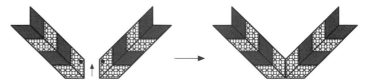

6. To make the center, sew the two units together, ending the stitching at the seam intersections indicated by the dots in the diagram.

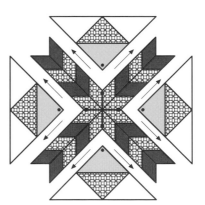

Center Unit

7. Sew the units made in step 2 to the completed center unit, stitching in the direction of the arrows. Follow the directions for set-in seams on page 5.

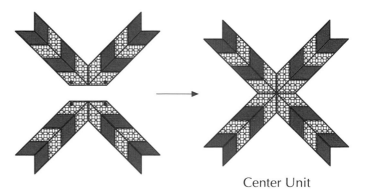

8. Mark the seam intersection at one corner of each square, Piece A, with a dot. Sew a Piece A to each corner, stitching in the direction of the arrows.

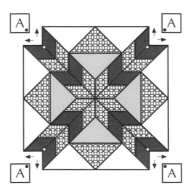

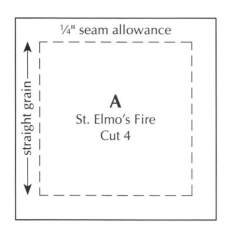

¼" seam allowance

A
St. Elmo's Fire
Cut 4

straight grain

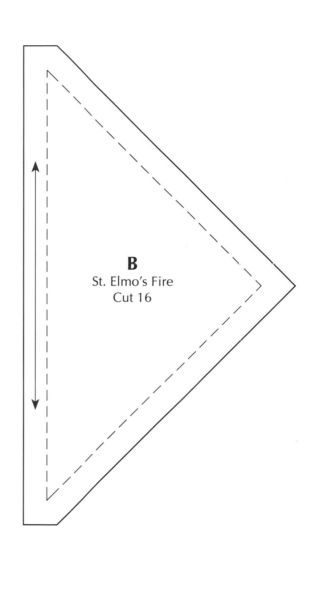

B
St. Elmo's Fire
Cut 16

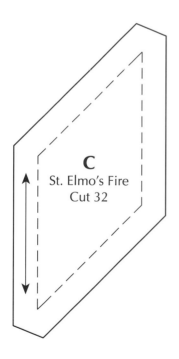

C
St. Elmo's Fire
Cut 32

Pilot's Wheel

Sunset and evening star,
And one clear call for me!
And may there be no moaning of
the bar,
When I put out to sea.

(Alfred, Lord Tennyson,
"Crossing the Bar")

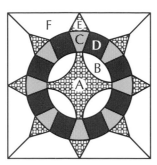

Pilot's Wheel
Finished size: 12"

Cutting

All measurements include ¼"-wide seam allowances.
Use Templates A, B, C, D, E, and F on page 38.
Mark the seam intersections on all pieces as
shown for set-in seams on page 5.

Piece A
Cut 1 Template A from medium blue print.
Mark center on each side.

Piece B
Cut 4 Template B from background fabric.
Mark centers on both sides of each piece.

Piece C
Cut 8 Template C from medium blue solid.

Piece D
Cut 8 Template D from dark blue solid.

Piece E
Cut 8 Template E from medium blue print.

Piece F
Cut 4 Template F and 4 Template F reversed
from background fabric.

Directions

1. Sew a Piece B to each side of Piece A to make Unit #1. Follow the directions for curved seams on page 5.

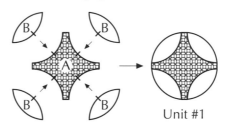

Unit #1

2. Sew Pieces C and D together to form a ring for Unit #2.

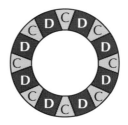

Unit #2

3. To complete the center unit, pin Unit #1 and Unit #2 with right sides together, carefully matching each end of Piece A with a Piece C in the ring. Stitch with Unit #2 on top.

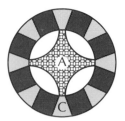

Center Unit

4. Sew a Piece F to sides of each Piece E, stitching in the direction of the arrows and sewing the seam between the two F pieces last. Follow the directions for set-in seams on page 5. Then add a Piece E to the right end of each F/E/F unit to complete the corner unit.

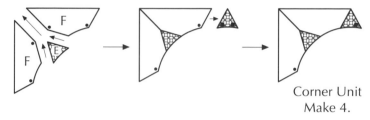

Corner Unit
Make 4.

5. Pin 1 completed corner unit to the completed center unit, matching each Piece C to a Piece E. Stitch, beginning and ending at the seam intersections indicated by the dots in the diagram.

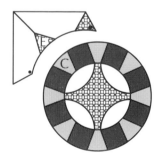

Repeat with the remaining corner units.

6. Complete the seams between the corner units (indicated by the arrows), stitching from the center circle to the outer edge of the block.

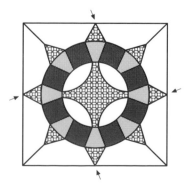

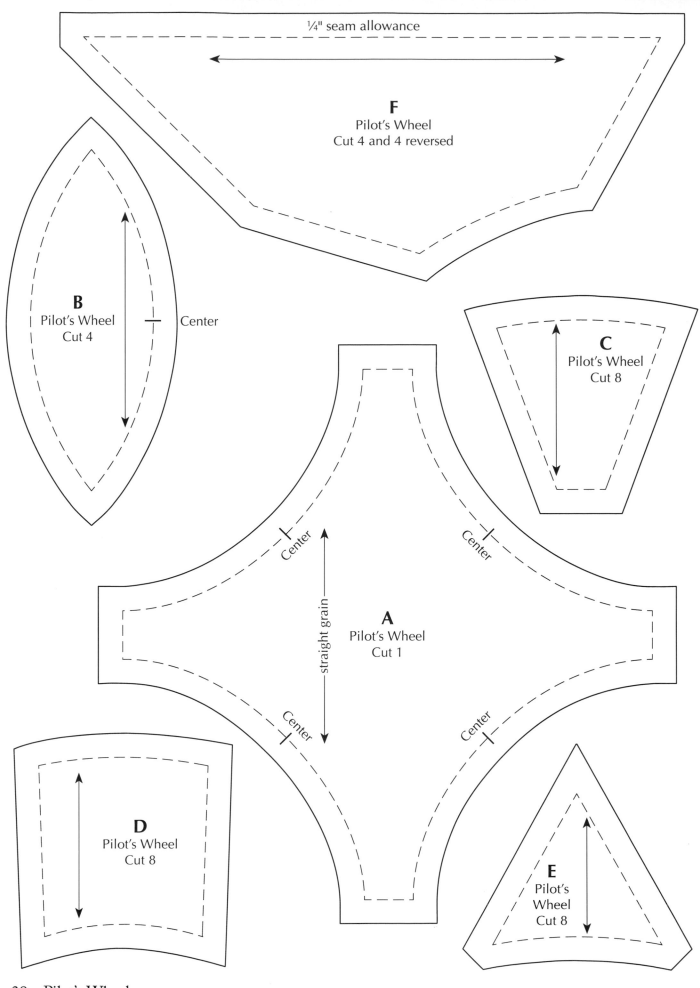

¼" seam allowance

F
Pilot's Wheel
Cut 4 and 4 reversed

B
Pilot's Wheel
Cut 4

Center

C
Pilot's Wheel
Cut 8

Center

Center

straight grain

A
Pilot's Wheel
Cut 1

Center

Center

D
Pilot's Wheel
Cut 8

E
Pilot's
Wheel
Cut 8

Make four Mariner's Compass blocks, one for each outer corner of the quilt. You may substitute another block for the corner blocks if you prefer.

Cutting

All measurements include ¼"-wide seam allowances. Use Templates A, B, C, D, and E on page 41. Mark the seam intersections on all pieces as shown for set-in seams on page 5.

For 4 blocks:

Piece A
Cut 4 Template A from dark blue print.

Piece B
Cut 32 Template B from dark blue print.

Piece C
Cut 32 Template C from medium blue print.

Piece D
Cut 64 Template D from background fabric.

Piece E
Cut 16 Template E from background fabric.

Directions

*It is an ancient Mariner,
And he stoppeth one of three.
"By thy long gray beard and glittering eye,
Now wherefore stopp'st thou me?*
(Samuel Taylor Coleridge, "The Rime of the Ancient Mariner")

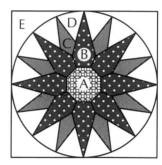

Mariner's Compass
Finished size: 12"

1. Sew a Piece D to sides of each Piece C.

Make 32.

2. Sew a Piece B to the right-hand edge of each D/C/D unit, beginning at the seam-intersection dots. Stitch in the direction of the arrow. Backstitch, being careful not to stitch past the dot.

Make 32.

3. Sew the base of Piece B to the center octagon, Piece A. Begin and end stitching at the seam intersections indicated by the dots in the diagram.

4. Sew the next unit to Piece A in the same manner. Then, stitch the two pieces together, stitching in the direction of the arrows. Backstitch at the seam intersections indicated by the dots in the diagram.

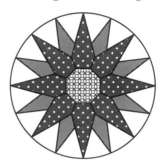

5. Continue adding the remaining pieced units in the same manner until you have added one to each edge of the octagon.

6. Sew a Piece E to each corner of the completed unit, matching the center of Piece E to the tip of the compass point. Follow the directions for curved seams on page 5.

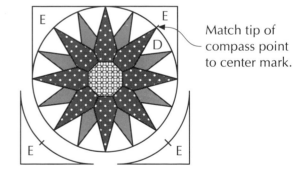

Match tip of compass point to center mark.

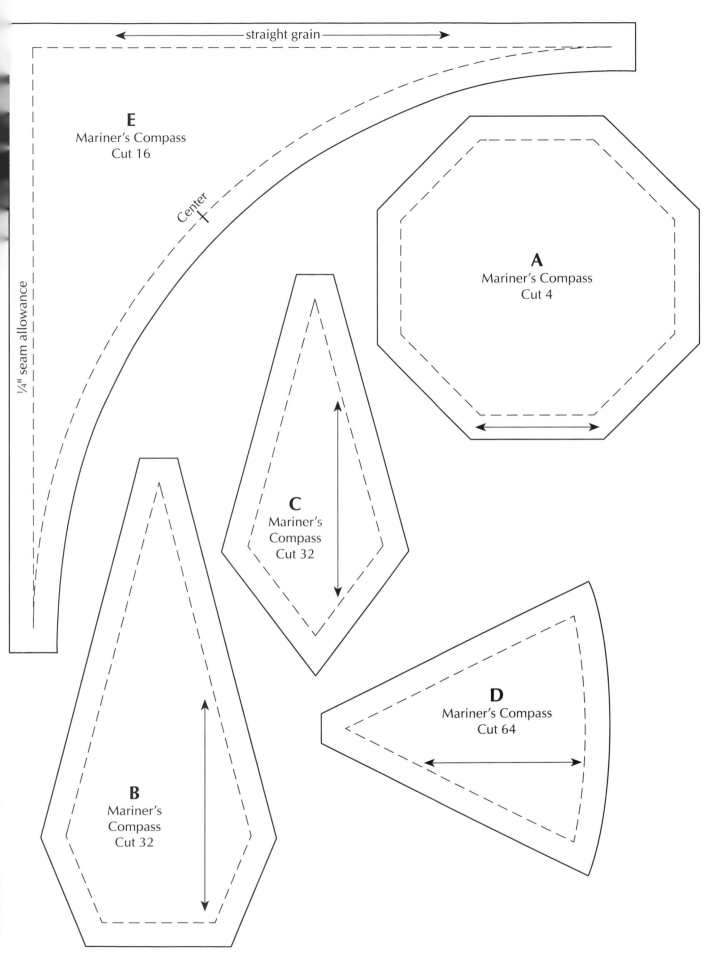

straight grain

E
Mariner's Compass
Cut 16

¼" seam allowance

Center

A
Mariner's Compass
Cut 4

C
Mariner's
Compass
Cut 32

B
Mariner's
Compass
Cut 32

D
Mariner's Compass
Cut 64

Quilt Top Assembly

1. Sew blocks and sashing strips together in 2 horizontal rows as shown. **Note:** You may change the order of the blocks in these rows if you wish.

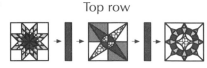

Top row

Bottom row

2. Sew 1 sashing strip to the bottom edge of the top row of blocks and 1 sashing strip to the top edge of the bottom row of blocks.

Top row

Bottom row

3. Sew the completed rows to the top and bottom edges of the Storm at Sea center unit.

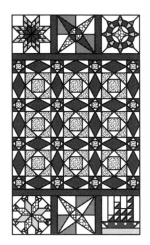

4. Sew 5 blocks and 4 short sashing strips together vertically, beginning and ending the row with a Mariner's Compass block (or other block of your choice). Make 2 rows, one for the left side and one for the right side of the center unit.

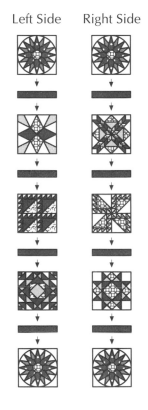

Left Side Right Side

5. Sew 1 long sashing strip to each side of each vertical block row.

Left Side Right Side

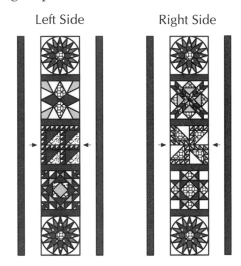

6. Stitch blocks and sashing units to the right and left sides of center unit.

Top

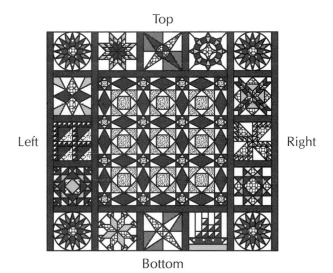

Left Right

Bottom

7. Sew the remaining 2 long sashing strips to the top and bottom edges of the quilt top.

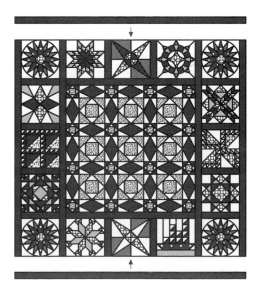

Ocean Waves Border

The breaking waves dashed high
On a stern and rock-bound coast
And the woods, against a stormy
* sky,*
Their giant branches tossed.
 (Felicia Dorothea Hemans,
 "The Landing of the Pilgrim
 Fathers")

Cutting and Assembly

1. From the remaining fabrics, cut bias strips 2½" wide and 8"–12" long. With right sides together, sew 1 print to 1 medium blue solid strip of similar length along one long edge. Make sure the bottom edges are even. Repeat with the remaining strips, then sew strip pairs together in groups of 4 strips each, keeping the bottom edges even in each group. The top edges will not be even.

2. Using the Bias Square, cut 204 bias squares, each 2⅝" x 2⅝". You need 51 bias squares for each border.

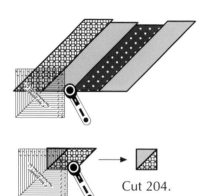

Cut 204.

To cut bias squares:
Position the Bias Square on the strip-pieced unit, aligning the diagonal line with the seam and positioning it so the first cuts will be slightly larger than 2⅝". Make the first 2 cuts to separate the square from the pieced unit.
Then turn the cut piece around, position the Bias Square for a 2⅝" square, and cut the remaining edges. Continue cutting bias squares in this manner until you have cut 204.

3. Cut 3 strips, each 4¼" x 42", from medium blue solid. Crosscut into 27 squares, each 4¼" x 4¼". Stack squares and cut twice diagonally to yield 108 triangles.

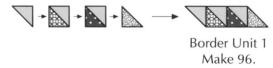

Triangles cut in this manner have straight grain on the long edges to prevent stretching along the outer and inner edges of the border.

4. Cut 24 squares, each 4¼" x 4¼", from different prints. Cut twice diagonally to yield 96 triangles.

5. Using bias squares and a medium blue triangle on the left and assorted print triangles on the right, make 96 Border Unit 1 as shown.

Border Unit 1
Make 96.

6. Using the remaining bias squares and triangles, make the units shown. You should have 4 medium blue solid triangles remaining.

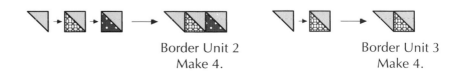

Border Unit 2
Make 4.

Border Unit 3
Make 4.

7. Assemble 4 border strips made of 24 Unit 1. Sew them together in diagonal rows and add a Unit 2, then a Unit 3 and finally a medium blue solid triangle to the right-hand end as shown.

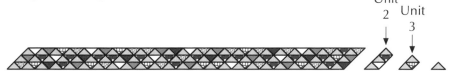

8. Matching centers, sew all 4 borders to the quilt top, beginning and ending the stitching exactly ¼" from the raw edge at the end of each border seam. Backstitch carefully to secure the stitches.

Note: If your pieced borders do not fit the finished quilt top, you may need to ease them onto the quilt. If the difference is more than ½", try taking a few slightly narrower or deeper seams in the pieced border to make them fit.

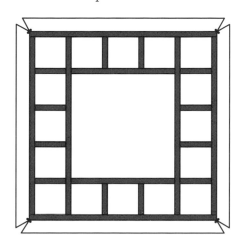

9. Stitch the diagonal seam to join the borders at each corner. Press the seams open.

Finishing the Quilt

1. Press the completed quilt top and mark it for quilting. Make templates for the cable quilting pattern on pages 46–47 and mark them on the sashing strips. Mark any additional quilting designs in the center and in the individual blocks as desired.
2. Layer the quilt top with batting and backing; baste.
3. Quilt as desired.
4. Bind the edges and sign your quilt.

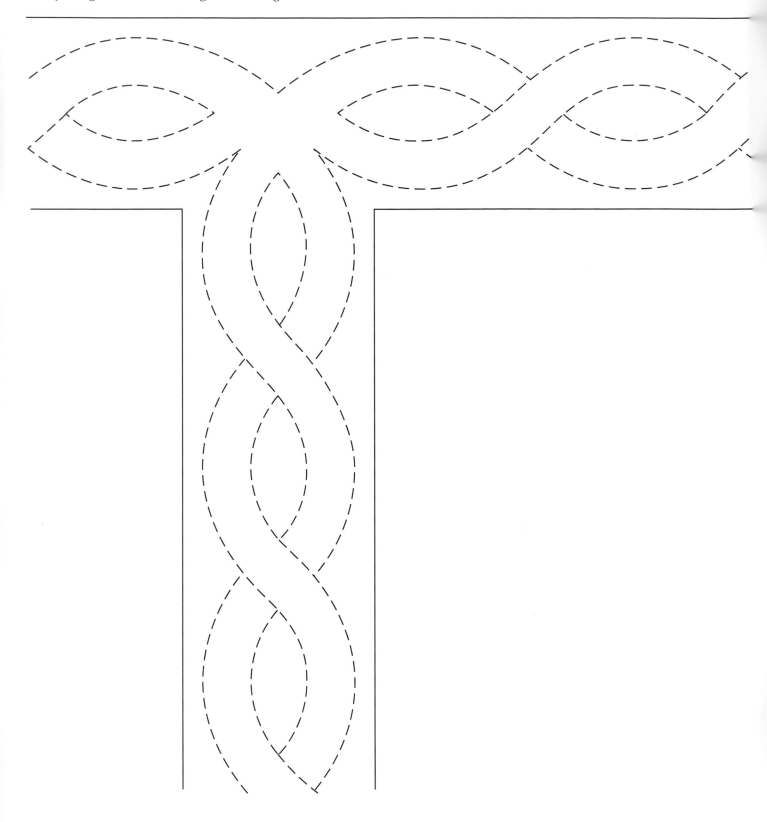

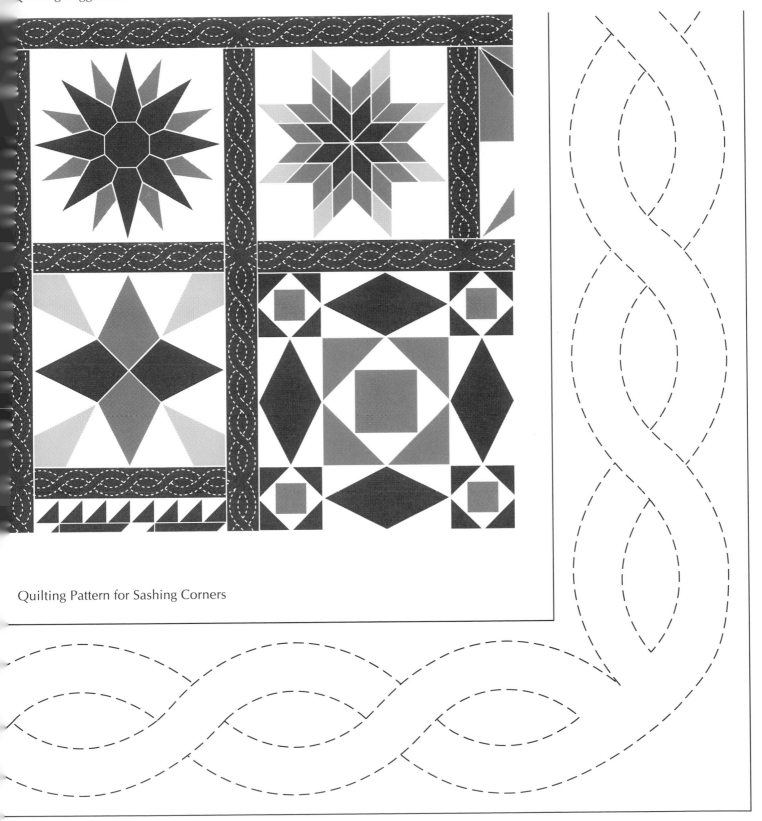

Quilting Pattern for Sashing Corners

*R*osemary grew up in Nova Scotia, where she learned the basics of quiltmaking from her mother. Her love of sewing and fabric led her to major in home economics at Acadia University; she taught high school "Family Studies" for several years following college.

Rosemary's interest in quiltmaking was rekindled when she made a baby quilt for her daughter, Candice. She began teaching Adult Education quilting classes and soon after founded the local Halton Quilters' Guild. Rosemary now teaches many classes and workshops and enjoys the special fellowship and inspiration that come from working closely with other quilters.

A traditional quiltmaker, Rosemary loves appliqué but makes many pieced quilts as well. Often, the quilts are her own design, but if not, she changes or adds something to make them distinctive.

Rosemary lives in Burlington, Ontario, Canada, with her husband, Chris, and their two children, Candice and Kenneth.